Treasures from the National Museum of Korea

Treasures from the National Museum of Korea

The Museum of Fine Arts, Houston

Treasures from the National Museum of Korea was organized by the Museum of Fine Arts, Houston,
and displayed in the Arts of Korea Gallery.
Generous funding was provided by the Korea Foundation.

This gallery was established with support from the Korea Foundation.
이 한국실은 한국국제교류재단의 지원으로 설치되었습니다.

Publications Director: Diane Lovejoy
Editorial Manager: Heather Brand
Designer: Janet Young
Photographer: Kim Kwang-seop unless otherwise noted

Note: Korean and Japanese names listed in this catalogue appear with the surname first.
All dimensions are listed in the following order, unless otherwise noted: height × width × length.

Printed in the United States by Chas. P. Young Co.

Library of Congress Cataloging-in-Publication Data
Treasures from the National Museum of Korea.
 p. cm.
Issued in connection with an exhibition held Dec. 9, 2007–Dec. 15, 2008, Museum of Fine Arts, Houston.
Summary: "Presents the arts of Korea from the Neolithic Age through the nineteenth century, including
stoneware, celadon, porcelain, and buncheong wares, gold crowns, Buddhist statues, bells, and ewers,
and personal ornaments in metal from the National Museum of Korea"—Provided by publisher.
Includes bibliographical references.
ISBN 978-0-89090-159-5 (hardcover: alk. paper)
1. Art, Korean—Exhibitions. 2. Art—Korea (South)—Seoul—Exhibitions. 3. Kungnip Chungang Pangmulgwan
(Korea)—Exhibitions. I. Kungnip Chungang Pangmulgwan (Korea) II. Museum of Fine Arts, Houston.
N7362.T74 2007
709.519'0745195—dc22
2007035634

Cover: Detail of Jar, 17th century, Joseon dynasty (1392–1910), porcelain with dragon
and cloud design in iron brown, National Museum of Korea, Deoksu 6234.

National Museum of Korea
Arts of Korea Gallery of the Museum of Fine Arts, Houston

Museum of Fine Arts, Houston

Dr. Peter C. Marzio, Director

Christine Starkman, Curator, Asian Art

Vivian Li, Curatorial Assistant, Asian Art

Jack Eby, Exhibition Designer

Beth Schneider, former W.T. and Louise J. Moran Education Director

National Museum of Korea

Dr. Kim Hongnam, Director-General

Planned by Kim Seong-Gu, Lee Seseop, and Yi Younghoon

Supervised by Choi Eungchon and Kwak Dongseok

Curated by Choi Seonju, Han Soo, Sun Seunghye, and Shin Soyeon

Lee Hyunsuk, Exhibition Designer

Huh Won, Graphic Designer

Kim Kwang-seop, Photographer

Contributors of Catalogue

Choi Eungchon—*Korean Buddhist Bells* and Plate 15

Hwang Jihyun—*Personal Ornaments* and Plates 27–33

Han Soo—Plate 2

Huh Hyeonguk—Plate 12

Jin Jounghwan—*The Contemplative Bodhisattva* and Plates 10 and 11

Kang Kyungnam—*Porcelain and Buncheong Ware of the Joseon Period*

Kim Hyunjung—*Goryeo Celadons* and Plates 16–19

Kim Kyudong—*The Gold Crowns of Silla, Stoneware of the Three Kingdoms Period*, and Plates 3–9

Kim Sangtae—*Comb-pattern Vessels of the Neolithic Age* and Plate 1

Kwon Sohyun—*Porcelain and Buncheong Ware of the Joseon Period*

Lee Aeryung—Plates 20–25

Park Kyungeun—*Goryeo Dynasty Ritual Ewers* and Plate 13

Shin Myunghee—Plates 14 and 26

Translators

Nam Kyunghee

Choi Eunjung

Dr. Kumja Paik Kim, Special Consultant for Korean Art Gallery and Translations Editor

Contents

Foreword

South Korea descends from a culture dating back five thousand years. Yet despite its origin in antiquity, South Korea is a nation of the future. This duality of yesterday and tomorrow is what makes South Korea a unique place in the world, a concept that is not so well understood in the United States.

As for ancient Korea, comparatively little of its prosperous past has survived. Conquering armies from the west, north, and east have destroyed so much of Korea's artistic heritage that Korean antiquities now are among the rarest and most expensive in the world. Present-day Korea is divided into two nations (North and South) with radically different political and social systems. Although numerous attempts are being made to unite the two, prospects of success seem bleak.

Nevertheless, South Korea's multifaceted identity inspires admiration. The nation embraces its traditions, with an eye toward accepting the various political, diplomatic, and economic options in play today. Furthermore, South Korea is confidently and aggressively pursuing global pathways of communication and manufacturing, once again demonstrating its strong national character and Janus-headed vision.

To be Korean is to respect and honor the past, all the while leading the world in international technology. This complex identity is reflected in the diverse works chosen for display in the new permanent collection gallery of Korean art at the Museum of Fine Arts, Houston.

Fifteen years ago the MFAH acquired its first Korean artwork—a seventeenth-century porcelain *Phoenix Jar*. Since that time, the Museum of Fine Arts, Houston, has gradually added other important Korean works to its collection, including a storage jar dating from the fourth century. This significant acquisition, made possible in 1995 with the support of Houston's Korean-American community and the Asia Society, strengthened the museum's bonds to the local Korean community—the largest in Texas. It also prompted the creation of a permanent exhibition devoted to Asian art in 1997. Now, ten years later, the MFAH is opening a permanent gallery devoted exclusively to the art of Korea— both old and new. This new Arts of Korea Gallery is the first of its kind in the Southwest.

As the museum's holdings have grown, so has its relationships both locally and internationally. Through unprecedented long-term loans, the MFAH's partnership with the National Museum of Korea will bring national treasures to Houston, treasures that have never left their native land before. These objects will illuminate visitors with the beauty and artistry of this ancient culture. The juxtapositions of works span five thousand years, from Neolithic times into the digital age. Early cultural artifacts are displayed beside works by contemporary artists, enabling us to delve into the rich culture of Korea across generations. The MFAH is dedicated to providing a venue for showcasing Korea's vast legacy for generations to come.

We give special thanks for their strong support to Honorable Kwon In Hyuk, former president of the Korea Foundation, and Honorable Yim Sung-joon, president; Chung Yang-mo, director emeritus of the National Museum of Korea, and Kim Hongnam, director; the Amore Museum; Yang Bong-Yul and Min Dong-Seok, former consul generals of Korea in Houston, and Kim Jung-Keun, consul general of Korea in Houston; Yi Song-mi; Jin Roy Ryu, chairman and CEO of Poongsan Corporation; and Chong-Ok Matthews and the Houston Korean community.

Peter C. Marzio
Director
The Museum of Fine Arts, Houston

Foreword

On behalf of the National Museum of Korea, I would like to express my gratitude to the
Museum of Fine Arts, Houston, for providing the opportunity to share some of our historical
art with the American people.

Korea and the U.S. have had a very strong diplomatic relationship throughout the last century.
The cultural exchange between our two countries has flourished since the first Korean immigrants
set foot on U.S. soil about a hundred years ago.

The collaboration between our two museums will not only help create a window through which
the world can learn about Korean culture, but also will establish an important forum for a continuous
exchange of art and culture. The objects that will be displayed at the Museum of Fine Arts, Houston,
include prehistoric earthenware vessels, a golden crown from an ancient tomb, Buddhist images that
represent Korean religious life, celadons from the Goryeo period, and porcelains and women's personal
ornaments from the Joseon period. Together, these pieces create a visual story, giving the viewer a
glimpse into the rich history of the "Land of the Morning Calm."

I hope that, through this exhibit, viewers will also be able to experience the vitality and the commitment
of those who have inherited and developed this cultural tradition, and who continue to contribute to
culture in Asia and in the world at large.

My very special thanks must go to Director Peter Marzio and the staff at the Museum of Fine Arts,
Houston. I would also like to express my gratitude to the supporters of the Arts of Korea Gallery
project, especially to the Korean community in Houston, which has put so much time and effort into
spreading awareness of Korean culture.

Kim Hongnam
Director
National Museum of Korea

Acknowledgments

In the past four years, many people from all over the world have generously given their amazing support and efforts to every stage of the Arts of Korea Gallery project, from its conception to its grand opening. My profound gratitude goes to Chung Yang-mo, director emeritus, and Kim Hongnam, director, of the National Museum of Korea (NMK) for their enthusiasm and unwavering support of the magnificent loans from their museum's stellar collection to the Arts of Korea Gallery at the MFAH.

We are also grateful to the Korea Foundation for its generous and constant assistance in this important project. In particular, we wish to express our deep appreciation to Honorable Kwon In Hyuk, former president, and Honorable Yim Sung-joon, president, without whose strong backing this project would not have been made possible. Yang Bong-Yul and Min Dong-Seok, former consul generals of Korea in Houston, and Kim Jung-Keun, consul general of Korea in Houston, also kindly offered us their many resources in the local Korean community and abroad to help ensure the success of the Arts of Korea Gallery.

My sincere thanks also go to Yi Song-mi for helping to initiate the creation of a substantial program of Korean art at the MFAH and for facilitating our first contacts with the arts and culture community in Korea. She continued her close involvement with the project in an advisory role. I also am indebted to Raphael Bernstein, a trustee of the MFAH who introduced me to Yi Song-Mi and brought about this great collaboration.

I would also like to thank Cho In-Soo, assistant professor of art history at the Korean National University of Art, and Sunghye Theresa Park, assistant curator in the Department of Exhibitions at the NMK, for helping us establish the initial critical contacts at that museum. The staff at the NMK has been of tremendous and invaluable help managing the loans and arranging for the objects' safe arrival in Houston. Special thanks are due to Choi Eungchon, former head of the special exhibition team at the NMK, curators Sun Seunghye, Han Soo, Soyeon Shin, and staff members Cindy Kim and Souyeon Woo, who skillfully coordinated the NMK's resources for the Arts of Korea Gallery project.

Many of the curators at the NMK also lent their extensive knowledge and expertise in writing the essays and entries for the catalogue to create this fine scholarly contribution to the understanding of Korean art in the West. Kyonghee Nam, Choi Eunjung, and Choi Moonjung deserve recognition for diligently translating the essays and entries into English.

Colleagues in the field have been wonderfully supportive of the Arts of Korea Gallery from the very beginning. Keith Wilson, associate director and curator of ancient Chinese art at the Sackler Gallery, and Hyonjeong Kim Han, associate curator of Chinese and Korean art at the Los Angeles Country Museum of Art, kindly provided insight into developing a strong Korean art gallery and program from their extensive experiences. We also appointed Kumja Paik Kim, curator emerita, Asian Art Museum in San Francisco, to serve as the special consultant to the Arts of Korea Gallery, and she has done an exceedingly superb job in this position. Her invaluable advice and work on the Korean art catalogue, labels, and educational programs have been crucial to refining our presentation and educational programs of Korean art.

Many colleagues at the Museum of Fine Arts, Houston, helped to make the Arts of Korea Gallery and its related materials and programs a reality. Jack Eby, exhibit design director, and Bill Cochrane, exhibition designer, in collaboration with Huh Won and Lee Hyunsuk, exhibit designers at the NMK, designed and created the beautiful gallery space. Beth Schneider, the former W.T. and Louise J. Moran Education Director, Victoria Ramirez, interim education director and school programs manager, and George Ramirez, student programs manager, were greatly involved in the design of the interpretive materials in the gallery and offered their advice and expertise. Margaret Mims, public programs manager, coordinated the robust educational programming in conjunction with the opening of the Arts of Korea Gallery. Vivian Li, curatorial assistant for the Asian Art Department, organized the many details of the project and corresponded with the various people and institutional entities involved. Petrine Knight, administrative assistant to the Asian Art Department, carefully handled the clerical and administrative matters related with the exhibition and catalogue.

Geoffrey Dare, assistant registrar, worked in his customary efficient and thorough manner to manage the transportation of the loan objects from Korea and the new acquisitions in the Korean art permanent collection. In the Image Library, Marty Stein oversaw the cataloging and organization of all of the photography for the project. Under the organization of Richard Hinson and Michael Kennaugh, the MFAH Preparations Department physically handled the movement of the art pieces with its usual care and professionalism. Diane Lovejoy, publications director; Heather Brand, editorial manager; and Janet Young, associate graphic designer, lent their expert insight and sensibility to the content, layout, design, and production of the final elegant catalogue.

The development of the Korean art collection at the MFAH was most generously supported by various members of the Korean community. The Amore Museum and Jungwook Hong, chairman, CEO, and publisher of Herald Media, Inc., offered their advice and resources to different aspects of the Arts of Korea Gallery to ensure its success. The Korea Foundation and Poongsan Corporation, with the strong backing of its chairman and CEO, Jin Roy Ryu, contributed tremendously toward the construction of the gallery, and the local Korean community raised more than a million dollars. Chong-Ok Matthews, who led the fundraising efforts in the local Korean community, deserves special recognition for her unyielding diligence and dedication to the Arts of Korea Gallery. The Asian Art Subcommittee at the MFAH has also provided continuous support for the establishment of this gallery from the outset.

The Arts of Korea Gallery, though, would not have been made possible at all without the steadfast commitment of Peter C. Marzio, director of the MFAH. After his trip to Korea in 2004, he returned to Houston with a passion for the arts of Korea that he believed needed to be shared. In addition to planning the Arts of Korea Gallery, he encouraged me to organize a show on the important modern artist Suh Se-ok, which I am organizing with Barry Walker, curator of modern and contemporary art and prints and drawings at the MFAH, and a show on contemporary art from Korea, which the MFAH is currently co-organizing with the Los Angeles County Museum of Art.

Peter C. Marzio's vision and grasp of the importance of the Arts of Korea Gallery to Houston as well as to the southern U.S. was instrumental in giving the project momentum from the outset. Considering that the MFAH's permanent collection of Korean art is modest, it was understood that this project would be an ambitious undertaking—one that required our utmost attention. The celebrated opening of the Arts of Korea Gallery is not the end, but just the beginning of our endeavors to bring the beauty of Korean art and culture to Houston and the Southwest region of the United States.

Christine Starkman
Curator, Asian Art
The Museum of Fine Arts, Houston

Introduction
Kumja Paik Kim

Even as contemporary travelers to Asia refer to Korea as Asia's hidden treasure, they are often unaware that Korea is an ancient country in East Asia with a continuous history dating back to the first century B.C. While it shares Confucian ethical values with the other East Asian countries of China and Japan, Korea has its own language, its own culture, and its own customs quite distinct from those of its neighbors.

Prehistory

Through active archaeological surveys and excavations since the 1960s, limestone caves with human fossil bones have been discovered together with stone tools such as choppers, cleavers, and scrapers made in quartzite belonging to the Paleolithic period dating back to approximately 500,000 B.C. The best known of these Paleolithic caves are those located in North Korea in the vicinity of Pyeongyang and in the lower reaches of the Tuman (Tumen) River, and in South Korea in the east-central region, the east coast, north of Seoul, and the southwestern region in the middle reaches of the Geum River.[1]

The discussion of the material culture of Korea invariably begins with the Neolithic period (approximately 8000–1000 B.C.), which coincides with the decision made by nomadic people from Northeast Asia to discontinue their nomadic wanderings and settle in the Korean Peninsula. This momentous decision to settle down led them to build humble huts and to form small family-oriented settlements, each composed of approximately twenty to thirty inhabitants in each settlement. More than one hundred fifty Neolithic dwelling sites excavated so far have been located along rivers and coastal areas,[2] providing evidence that these people depended heavily on fishing for their subsistence, along with gathering, hunting, and incipient farming.

More important for the study of Korea's material culture, these Neolithic settlers were the earliest pottery makers. The vessels they made were nonvitrified, porous ceramic wares called earthenware, fired at approximately 800 degrees Celsius (1,472 degrees Fahrenheit) in open air. The importance of the low-fired Neolithic earthenware cannot be overstated in the history of Korean ceramics, for they mark the beginning of Korea's illustrious ceramic tradition, which has continued to the present day.

Regional differences distinguish Neolithic earthenware vessels made in various localities throughout the peninsula. The most commonly known regional differences can be seen in those discovered in the south in the Busan area, such as the bowl with appliqué designs over its surface, generally known as the Dongsam-dong style (fig. 1), and the bowls with flat bottoms discovered at Osan-ni (fig. 2) on the central eastern coast. The most famous Neolithic earthenware are undoubtedly the comb-pattern vessels with the pointed bottoms discovered at Amsa-dong in the Han River basin in Seoul.[3] The term "comb-pattern" derives from the slanted parallel lines made by incising, which resemble patterns made by a comblike implement. It is believed that the comb-pattern design originating in northwest Russia reached the Korean Peninsula across the Siberian steppe.[4]

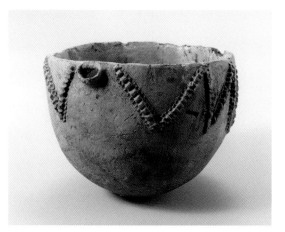

Figure 1

Bowl, c. 4000 B.C., Neolithic period, earthenware with appliqué designs, Dongsam-dong style, from Yeongseon-dong, Busan, Dong-A University Museum, National Treasure No. 597.

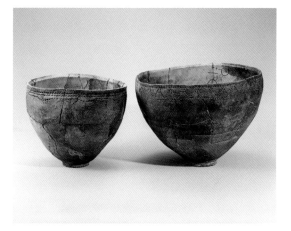

Figure 2

Bowls, c. 5000 B.C., Neolithic period, earthenware with flat bottom, Osan-ri style, from Osan-ni, Gangwon Province, Seoul National University Museum.

Another major migration of people into the Korean Peninsula took place about 1000 B.C. and initiated Korea's Bronze Age (1000–300 B.C.). These people are believed to have been of a Tungusic race, called the Yemaek in Korean, and are known as the megalithic-dolmen builders. Korean dolmens are gigantic stone structures believed to have served burial purposes. They were constructed with several upright stones forming the walls, which are covered by a single capstone on the top, functioning as the roof. They are generally divided into the southern and northern types. The southern type, which proliferates in the southern coastal area, has an appearance of a Go table with short legs, while the northern type, found in the northwestern area, looks like a regular table with long legs.[5] One of the largest dolmens of the northern type, found in Ganghwa Island near Seoul, is 2.6 meters (8 ½ feet) in height and has a capstone weighing 50 tons and measuring 7.1 meters (23 ¼ feet) in length and 5.5 meters (18 feet) in width (fig. 3). Despite the rapid disappearance of Korean dolmens in recent years, more than 30,000, approximately 40 percent of all dolmens in the world, have survived in Korea.

Unlike Korea's Neolithic inhabitants, who lived near the water, the builders of these dolmens constructed their dwelling sites on the slopes or the tops of low hills overlooking fields and streams. They cultivated a variety of grains, such as millet, sorghum, barley, soy beans, wheat, and, most important, rice,[6] and produced red[7] and black burnished earthenware (fig. 4).

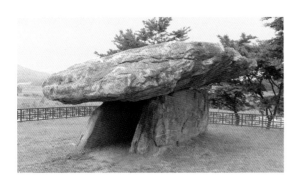

Figure 3
Dolmen, c. 1000 B.C., Bronze Age,
Ganghwa Island, Gyeonggi Province.

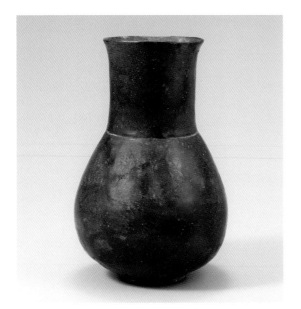

Figure 4
Jar, c. 400–300 B.C., Bronze Age,
earthenware, black burnished style,
from Goejeong-dong, Daejeon,
National Museum of Korea, Seoul.

As the name of this period indicates, the dolmen builders introduced bronze technology to Korea. Of the extant bronze artifacts, the most unusual are round bronze mirrors. Although the mirror form originated in China, unlike Chinese mirrors, which have a broad rim, one central knob, and a range of decorations on their reverse side, Korean mirrors are decorated with thin geometric parallel lines and have two off-center knobs. The Bronze Age designs became further refined during the succeeding Iron Age (300–50 B.C.). The mirrors made during the Iron Age are decorated with amazingly complex geometric designs as intricate as those fashioned by modern computers, consisting of concentric circles, triangles, rectangles, lozenges, and diamond shapes filled in with thin parallel lines, relating them to the arts of the Siberian steppe and Scythians. The Korean bronze mirrors with their intricate geometric designs (fig. 5) were among the artifacts that led the famous scholar of Japanese history George Sansom to comment that from early times Korean culture had a strong individual character resulting from the synthesis of diverse elements. Korea did not function as a mere bridge, but was the land where many cultural elements from China and northeast Asia as well as Schytho-Siberian cultural elements became amalgamated before being transmitted to Japan. This contributed to the idiosyncrasies noticeable in Japanese culture.[8]

Figure 5

Mirror, c. 300 B.C., Iron Age, bronze with geometric designs, from Yangyanggun, Gangwon Province, National Museum of Korea.

Three Kingdoms Period (57 B.C.–A.D. 668)

Discoveries from the tombs of the Three Kingdoms period have dazzled the world since the 1920s. They include tomb murals from the Goguryeo kingdom (37 B.C.–A.D. 668) in the north, personal belongings of King Muryeong (reigned 501–523) of the Baekje kingdom (18 B.C.–A.D. 660) and his queen from the undisturbed tomb in Gongju in the southwest, and gold crowns and ornaments from Gyeongju tombs of the Silla kingdom (57 B.C.–A.D. 668) in the southeast. Of the six gold crowns found in Gyeongju, five of them are from scientifically excavated tombs. Enough objects made of gold have been unearthed from these tombs befitting the description of Silla in the Japanese chronicle *Nihongi* as "the land of gold and silver" or "the land dazzling to the eye."[9]

The gold crowns excavated from the fifth- and sixth-century Silla tombs that have fascinated the world are made of cut-gold sheets forming the headband to which five uprights (vertical elements) have been attached.[10] Although very much abstracted, the three uprights in the center represent the tree of life, and the two at both ends represent antlers.[11] The surface of the band as well as the trees and antlers are covered with numerous circular gold dangles and comma-shaped jade pieces attached with gold wire. It is believed that the earliest dated drawn-gold wire in the world has come from the Silla tombs.[12]

These Silla crowns are related to Scythian or Scytho-Siberian art. The crown discovered from a Khokolach barrow in Novocherkask, now in the collection of the Hermitage in St. Petersburg, Russia, shows more naturalistically rendered trees, deer with large antlers, and rams with big horns on the top of the headband.[13] From the same place came a pair of ornaments that can be related to cut-gold dangles on Silla crowns. Also, a Scythian felt believed to have been used as a wall hanging discovered in the frozen tomb of Pazyryk in southeastern Russia has as the main motif a seated man wearing an oversized hat with triangle designs and holding a tall staff with a tree motif. He is visited by a mounted nobleman whose horse wears a comma-shaped jade on its neck, perhaps as a protective amulet or talisman.[14]

Many thousands of Silla stoneware[15] have been unearthed since the 1950s as a result of active highway construction and urbanization taking place in Korea. In order to produce stoneware that are stronger than earthenware and impervious to water, the most important prerequisite is to have the technology to raise the kiln temperature to 1,200 degrees Celsius (2,192 degrees Fahrenheit) or higher. Because Korea is a mountainous country with only about 25 percent of its land arable, it would have been unthinkable to use precious flat land for any other purpose than for the production of much-needed crops. Such a situation leaves only hillsides as suitable sites to build kilns. In these hillside firing chambers, the temperature is able to climb rapidly due to the way heat rises and the tunnel effect of the chamber's construction. As a result of this technological breakthrough, Korean ceramics made a smooth transition from the earthenware phase to the stoneware phase about A.D. 300. A wide range of robust and exciting stoneware forms were created during the Three Kingdoms period of Goguryeo, Baekje, and Silla, as well as in the Gaya states. They included jars and bowls with stands as well as tall stands and whimsical figural forms with stands (figs. 6–8).[16] These Three Kingdoms stoneware vessels had a direct influence on Japan's earliest stoneware called *Sueki* ware.

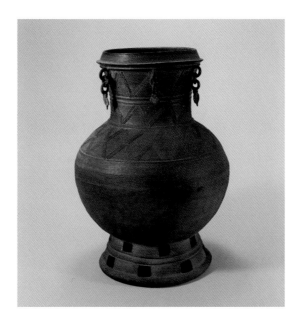

Figure 6

Jar, c. 450, Three Kingdoms period:
Silla, stoneware decorated with dangles
and stand, Gyeongju National Museum.

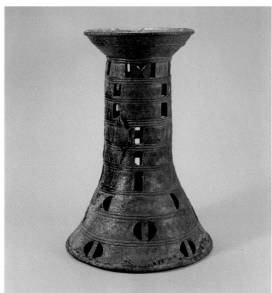

Figure 7

Stand, c. 450, Three Kingdoms period:
Gaya, stoneware decorated with openings,
Pusan National Museum.

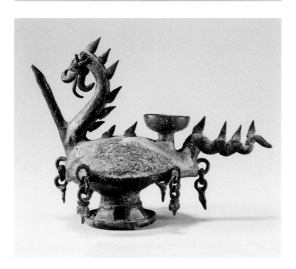

Figure 8

Ewer, c. 500, Three Kingdoms period:
Silla, stoneware in the form of a dragon,
from the King Michu's tumulus area,
Gyeongju, North Gyeongsang Province,
Gyeongju University Museum.

It was during the Three Kingdoms period that Buddhism, originating in India, was introduced to Korea via China.[17] By the early sixth century all three kingdoms had officially accepted Buddhism, which was used by rulers of each kingdom to unify the people under the centralized power. The Buddhist concepts of *karma* (cause and the effect) and *chakravartin* (universal kingship) became effective means for the kings to explain their own privileged positions in contrast to the state of life of the people they ruled.[18] With the official recognition and the support of rulers in all three kingdoms, temples and pagodas were built and many art forms were created in the service of Buddhism. In 539, in their effort to spread Buddhism throughout the world, the abbot and forty masters and disciples of the Dongsa temple in Pyeongyang in the kingdom of Goguryeo commissioned the production of one thousand Buddha images. The inscription on the back of the halo of the earliest extant gilt-bronze Buddha in Korea records this endeavor and identifies it as the twenty-ninth in the series. The fact that this image, made in Pyeongyang in the northwest, was discovered in Uiryeong, in the southeast, which at the time had been part of the kingdom of Silla, testifies to the missionary zeal of early Korean Buddhists (fig. 9).

Figure 9

Standing Buddha, 539, Three Kingdoms period: Goguryeo, gilt bronze, from Uiryeong, South Gyeongsang Province, National Museum of Korea, Seoul, National Treasure No. 119.

Unified Silla Dynasty (668–935)

The Silla kingdom, allied with the Tang dynasty in China, succeeded in unifying the whole of Korea by defeating the kingdoms of Baekje and Goguryeo in 660 and 668, respectively. The capital city of Gyeongju became the political, religious, and artistic center of unified Korea. With renewed vitality Buddhism flourished. New temples and pagodas were built and already existing Buddhist structures were expanded in order to accommodate the growing congregation. As the name of the most renowned Buddhist temple, Bulguk-sa (*bul*=Buddha, *guk*=nation, *sa*=temple) (fig. 10), indicates, there was a firm belief that Buddhism would protect the nation from all evil influences, including invasions. In front of the Golden Hall in the temple nucleus are two pagodas on either side, creating an unusual contrast. The simple pagoda is dedicated to the historical Buddha Shakyamuni (Seokga-tap) (fig. 11), and the ornate pagoda to Prabhutaratna, the Buddha of the Past (Dabo-tap) (fig. 12). It was from the simple Shakyamuni pagoda that the printed Dharani sutra on paper was discovered during its restoration in 1966. Because the pagoda was completed in 751, the terminal date of this sutra is attributed to 751, making it the oldest surviving printed text on paper in East Asia.

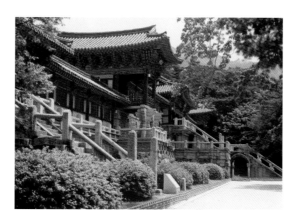

Figure 10

Bulguk-sa temple, 8th century,
Unified Silla dynasty, Gyeongju,
North Gyeongsang Province,
National Treasure No. 21.

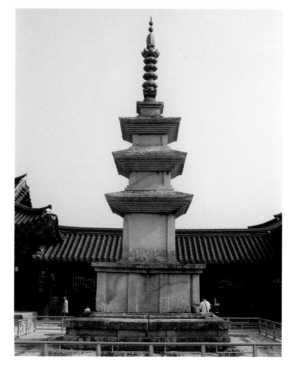

Figure 11

Seokga-tap (Shakyamuni pagoda), 751,
Unified Silla dynasty, stone, Gyeongju,
North Gyeongsang Province.

The companion structure of the Bulguk-sa temple is the Seokguram, the domed circular grotto constructed with granite approximately a mile away near the summit of Mount Toam. In the center of the grotto is a seated Buddha eleven feet high carved out of a single block of granite (fig. 13). Protected by guardian kings in the corridor and heavenly kings in the antechamber and surrounded by disciples and bodhisattvas inside the rotunda, the seated Buddha looks out serenely toward the East Sea. The Seokguram structure and the images of the Buddha and bodhisattvas within can be counted among the most outstanding artistic achievements epitomizing Buddhist art in Korea and in the world. Both Bulguk-sa and Seokguram are included in the UNESCO World Heritage List.

As Korea was transformed into a devout Buddhist state, the burial custom of people changed from that of inhumation to cremation. To meet the great demand for urns to hold the ashes of the deceased, cinerary urns were produced in quantity. The surface of these urns was often completely covered with a variety of stamped floral and geometric designs. These stamped designs are humble cousins of more color- ful designs profusely decorating the interior and the exterior of Buddhist temples to evoke the bejeweled realm of the Buddha or buddhas. Most important, some of these cinerary urns were intentionally covered with fine-quality ash glaze (fig. 14) or lead glaze (fig. 15).

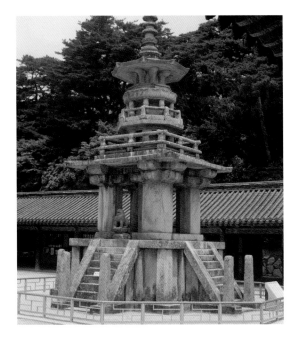

Figure 12
Dabo-tap (Prabhutaratna pagoda),
8th century, Unified Silla dynasty,
stone, North Gyeongsang Province,
National Treasure No. 20.

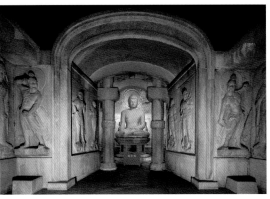

Figure 13
Seokguram cave, 8th century,
Unified Silla dynasty, stone, Gyeongju,
North Gyeongsang Province,
National Treasure No. 24.

Goryeo Dynasty (918–1392)

As the royal family of Unified Silla weakened, resulting from continuous infighting over succession toward the end of the dynasty, the central government lost its control in the provinces to the powerful regional families. Wang Geon (reign name: Taejo, reigned 918–943), from a gentry family with maritime background, emerged victorious among contenders to the power. In 918, he founded a new dynasty, which he named Goryeo, a contraction of Goguryeo, alluding to his descent from this illustrious ancient kingdom.[19] He practiced a policy of inclusiveness by political marriages and by embracing with the utmost generosity those who surrendered to him, including the last ruler of Unified Silla, King Gyeongsun (reigned 927–935); the ruler of Later Baekje, Gyeonhwon (reigned 900–935); and the last crown prince of Barhae kingdom (698–926), effectively creating an aura that Goryeo was the legitimate successor of all preceding Korean kingdoms. He established his capital at Gaegyeong (present-day Gaeseong), where his family had its power base.

Because Wang Geon firmly believed that his success in founding a new dynasty was due entirely to the protective powers of the buddhas,[20] Buddhism continued to flourish from the very beginning throughout the dynasty. All forms of art, especially Buddhist art, enjoyed the encouragement and the patronage of the kings, the royal court, the aristocracy, and the Buddhist institutions, producing astonishing achievements.

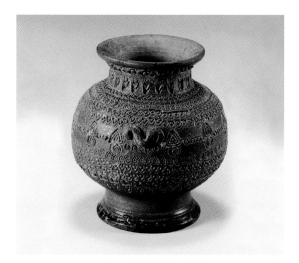

Figure 14

Cinerary Urn, 8th century, Unified Silla dynasty, stoneware with ash glaze, from Gyeongju, North Gyeongsang Province, Gyeongju National Museum.

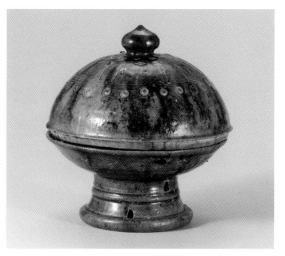

Figure 15

Cinerary Urn, 8th century, Unified Silla dynasty, stoneware with lead glaze, from Gyeongju, North Gyeongsang Province, National Museum of Korea.

More than one hundred and thirty Goryeo Buddhist paintings have survived. Among them are some spectacular examples. A painting of Avalokiteshvara (Korean: *Gwanse-eum-bosal*) dated 1310 in the collection of Kagami Jinja, a shrine in the Saga Prefecture in Japan,[21] is considered one of the most outstanding Buddhist paintings in the world. During the Goryeo dynasty, in addition to Buddhist paintings, the finest illuminated sutras were produced by artisans employed at the Royal Scriptorium of Gold Letters (*Geumja-won*) and the Royal Scriptorium of Silver Letters (*Eunja-won*) at the court. Their works were so admired that the Chinese Yuan court invited one hundred Goryeo artisans specializing in producing illuminated sutras to produce sutras for the Yuan court in 1290 and again in 1305.[22]

With the sincere devotion to Buddhism and the strong belief in the power of buddhas and bodhisattvas to save the country and people, the Goryeo court carried out two monumental projects of carving wood-blocks containing the complete set of the Buddhist canon in 1087 and again in 1251. The 81,258 woodblocks, which were carved on both sides and were completed in 1251, are believed to be the most complete surviving Buddhist canon in the world and are known as the *Tripitaka Koreana*. *Tripitaka* means three baskets—which refer to sutras, laws, and treatises. The Tripitaka Koreana, stored in the repositories at the Haein-sa monastery near Daegu (fig. 16), is also on the UNESCO World Heritage List.

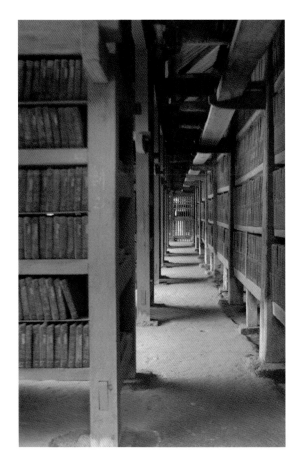

Figure 16

Tripitaka Koreana, 1251, Goryeo period, repository of Haein-sa monastery, North Gyeongsang Province, National Treasure No. 32.

Goryeo celadons are undoubtedly the most celebrated Korean art form. They have gained such prominence that Goryeo ceramics have become synonymous with Goryeo celadons. Production of this stoneware with a bluish or grayish-green glaze began in Korea in the late ninth century, during the Unified Silla dynasty, and reached its height in the first half of the twelfth century. For Goryeo potters, producing high-quality celadons fired at a high temperature in a reducing atmosphere was, technologically, only a short step from the production methods required for ash-glazed stonewares that were fully developed during the Unified Silla dynasty. In the eleventh and twelfth centuries, only two countries in the world had the technological expertise to produce celadons: China and Korea. Although inspired and influenced initially by Chinese ceramic wares,[23] Goryeo potters produced exquisite celadon wares that have been sought-after because of the beauty of their form, decoration, and glaze. Since the twelfth century, Goryeo celadons have been held in the highest esteem by collectors and connoisseurs, winning a place among those things counted as the "First under Heaven."[24] Additionally, Goryeo potters made contributions to the world of ceramic art by incorporating the inlay technique and using underglaze copper oxide to decorate celadons.[25]

Joseon Dynasty (1392–1910)

The Joseon dynasty was founded in 1392 by the powerful Goryeo military commander Yi Seong-gye, who named the dynasty after Korea's most ancient kingdom and moved its capital to Hanyang, present-day Seoul. Yi Seong-gye (reign name: Taejo, reigned 1392–1398) allied himself with a group of reform-minded Confucian scholars and reorganized Joseon society by rejecting Buddhism and adopting Neo-Confucian teachings as the new dynasty's guiding principle, emphasizing order and peace based on harmonious interpersonal relationships and proper conduct. The Joseon dynasty is often characterized as *yangban* society, named after the educated gentry class who ruled the country.[26]

Arts of the Joseon dynasty generally mirror the taste of the yangban class. From the beginning of the dynasty, the Joseon rulers and scholar-officials in power, steeped in Neo-Confucianism, preferred simple white porcelain wares over elegant celadons, which had been favored during the preceding Goryeo dynasty (918–1392). To them, the color white symbolized purity, honor, and modesty. King Sejong (reigned 1418–1450), for instance, ordered exclusively white porcelain wares be used for his table.

Among decorated porcelain wares, those decorated with underglaze cobalt, called *cheonghwa baekja* in Korean and commonly known as "blue and white," were first produced with cobalt imported from China during the second quarter of the 1400s. Although cobalt was discovered in Korea in 1464, the imported cobalt that produced clear, light-blue tones was preferred over the native cobalt, which gave dark and uneven blue tones. Porcelain wares decorated with underglaze iron and copper oxide also became prevalent from the 1600s onward.[27] In many Joseon porcelain wares decorated with under-glaze cobalt, iron oxide, and copper oxide, the Korean preference for empty space and asymmetrical composition, as seen in the designs for Bronze Age artifacts such as bronze mirrors, continued.

Stoneware decorated with white slip called *buncheong*[28] were the offspring of inlaid celadons. Unlike porcelain wares, which were initially made exclusively for court usage, buncheong were made from the beginning for everyone, commoners and aristocracy alike. The production of buncheong lasted for only two hundred years, ceasing after the Japanese invasions of Korea in 1592 and 1597.[29] During these two centuries, buncheong potters used different techniques to decorate pieces they made, including inlay (*sanggam*), stamped (*inhwa*), carved (*yanggak*), incised (*eumgak*), sgraffito (*bakji*), painted (*cheolhwa*), and overall white slip by brush (*gwiyal*) or by dipping (*damgeum* or *deombeong*). To embellish a single piece, a combination of two or three different decorative techniques, such as stamped and inlay or carving and sgraffito, were often used simultaneously. Regardless of the techniques used, it was essential for buncheong wares to feature the white slip prominently.[30]

Although this exhibition does not include calligraphy and painting, it must be pointed out that they were considered to be the highest forms of art in Korea. Gim Jeong-hui (1786–1856) and Jeong Seon (1676–1759) were towering figures in calligraphy and painting, respectively, during the Joseon dynasty in Korea. In painting, portraits of high officials and ancestors, landscapes of actual places rather than imaginary scenes (*jingyeong sansu*),[31] and genre paintings depicting everyday life of ordinary people became popular. From 1750 onward, many painters became acquainted with Western techniques of linear perspective and chiaroscuro. In contrast to the restrained ink paintings catering to yangban taste, folk paintings produced for mass consumption were refreshingly creative in their use of bold colors and playfully abstract forms.[32]

In all forms of art, familiarity leads to understanding and appreciation. The objects from the National Museum of Korea included in the exhibition celebrating the opening of the Korean art gallery at the Museum of Fine Arts, Houston, provide an opportunity for many people to encounter Korean art firsthand. This auspicious encounter will be the first of many in fostering a deeper understanding and appreciation of Korean art and culture.

Notes

1

Yim Hyo-jae, *Hanguk ui Seonsa Munhwa* [*Prehistoric Culture of Korea*], exh. cat. (Seoul: Seoul National University Museum, 1986), 60–61.

2

Ibid., 61–63; Kim Won-yong, *Art and Archaeology of Ancient Korea* (Seoul: Taekwang Publishing, 1986), 29–35.

3

The terms Dongsam-dong style, Osan-ni style, and Amsa-dong style are used to designate the Neolithic earthenware vessels with appliqué designs, with flat bottoms, and with comb-pattern designs with pointed bottoms, respectively. They are the names of sites from which the earthenware vessels of different styles had been first discovered. See "Comb-Pattern Vessels of the Neolithic Age" in this catalogue, pp. 25–29, and for an example of the Amsa-dong comb-pattern vessel type with the pointed bottom, see plate 1.

4

Kim Won-yong, *Art and Archaeology of Ancient Korea*, 29–35.

5

Ibid., 35–41, 134–38.

6

Ibid., 36. The rice pollen was discovered in a stratum datable to 1500 B.C. in Muan in southwestern Korea.

7

For a typical red burnished jar, see plate 2 in this catalogue.

8

George Sansom, *Japan: A Short Cultural History* (New York: Meredith, 1962), 1–21.

9

W. G. Aston, trans., *Nihongi, Chronicles of Japan from the Earliest Times to A.D. 697*, (1972; repr., Rutland, VT, and Tokyo: Charles E. Tuttle, 1988), 221.

10

See "The Gold Crowns of Silla" in this catalogue, pp. 47–55.

11

For a typical Silla gold crown, see plate 9 in this catalogue.

12

This information came from a conversation with Donna Strahan, the former head of the conservation department at the Asian Art Museum, San Francisco. She is currently working at the Metropolitan Museum of Art, New York.

13

J. Edward Kidder, *Early Japanese Art (The Great Tombs and Treasures)* (Princeton, NJ: D. Van Nostrand, 1964), fig. 13.

14

Ibid., fig. 14.

15

See "Stoneware of the Three Kingdoms Period" in this catalogue, pp. 33–39.

16

See Kumja Paik Kim, *The Art of Korea: Highlights from the Collection of San Francisco's Asian Art Museum* (San Francisco: Asian Art Museum, 2006), plates 2–11.

17

Buddhism was officially accepted by the northern kingdom of Goguryeo in 372, by the southwestern kingdom of Baekje in 384, and finally by the kingdom of Silla in 527. It was the Baekje kingdom that introduced Buddhism officially to Japan in 538, ushering in Japan's first historical period of Asuka (538–645).

18

Lewis R. Lancaster, *Introduction of Buddhism to Korea: New Cultural Patterns and Assimilation of Buddhism in Korea* (Berkeley: Asian Humanities Press, 1989); Lewis R. Lancaster, Kikun Suh, and Chai-shin Yu, *Buddhism in Koryo: A Royal Religion* (Berkeley: Institute of East Asian Studies, University of California, Center for Korean Studies, 1996); Lewis R. Lancaster and Chai-shin Yu, eds., *Buddhism in the Early Choson: Suppression and Transformation* (Berkeley: Institute of East Asian Studies, University of California, Center for Korean Studies, 1996).

19

The name Korea is derived from Goryeo. Korea became known to the outside world beyond East Asia during the dynasty of Goryeo, which China called *Gaoli* and Japan *Korai*.

20

See Wang Geon, "Ten Injunctions" in Peter H. Lee, ed., *Sourcebook of Korean Civilization*, vol. 1 (New York: Columbia University Press, 1993), 263–66.

21

See plate 8 in Kumja Paik Kim, *Goryeo Dynasty: Korea's Age of Enlightenment*, exh. cat. (San Francisco: Asian Art Museum, 2003).

22

Pak Youngsook, "Illuminated Buddhist Manuscripts in Korea," *Oriental Art* 33, no. 4 (Winter 1987–1988): 357–74.

23

Korean celadons were inspired by Chinese *yue*, *ding*, *yaozhou*, *chingbai*, *ru*, and *cizhou*.

24

For further reference on Korean celadons, see G. St. G. M. Gompertz, *Korean Celadon and Other Wares of the Koryo Period* (London: Faber and Faber, 1963); Kumja Paik Kim, *Goryeo Dynasty: Korea's Age of Enlightenment*, 17–19, and 232–315.

25

For examples of Goryeo celadon, see plates 16–19 in this catalogue; Itoh Ikutaro and Mino Yutaka, *The Radiance of Jade and the Clarity of Water: Korean Ceramics from the Ataka Collection*, exh. cat. (Chicago: The Art Institute of Chicago, 1991), plates 15–23, 32, 34, 39, 41–43, 32, and 44.

26

Yangban, meaning the "two orders," refers to the civil and military branches of officialdom that governed the state according to the rules and regulations laid out in the national code. Appointments to government posts, the gateway to success, were achieved through state examinations. Although in theory anyone could take the examinations, in reality they were open only to the men of the *yangban* class who were privileged to receive certain types of higher education.

27

For examples of Joseon blue and white and porcelain with underglaze iron oxide, see plates 23–25 in this catalogue; Itoh and Mino, *The Radiance of Jade and the Clarity of Water: Korean Ceramics from the Ataka Collection Collection*, plates 71–114.

28

Buncheong is an abbreviation of *bunjang hoecheong sagi* meaning "white-slip-decorated grayish-blue stoneware."

29

Many Korean potters were taken to Kyushu, Japan, as prisoners of wars between 1592 and 1598. These Korean potters discovered in Kyushu the *kaolin* or china clay essential for the production of porcelain and began Japan's porcelain industry in the seventeenth century.

30

For examples of different types of buncheong, see plates 20–22 in this catalogue; Itoh and Mino, *Korean Ceramics from the Ataka Collection*, plates 45–68.

31

For in-depth discussion of Korean landscape painting, see Yi Song-mi, *Korean Landscape Painting: Continuity and Innovation Through the Ages* (Seoul and Elizabeth, New Jersey: Hollym, 2006); Burglind Jungmann, *Painters as Envoys: Korean Inspiration in Eighteenth-Century Japanese Nanga* (Princeton and Oxford: Princeton University Press, 2004); Choi Wan-su, *Korean True-View Landscape Paintings by Chong Son (1676–1759)*, ed. and trans. Youngsook Pak and Roderick Whitfield (London: Saffron Books, 2005).

32

For general discussion of Korean painting, see Kumja Paik Kim, *The Art of Korea*, 25–48, plates 49–84.

The Three Kingdoms
at the Height of Goguryeo Expansion

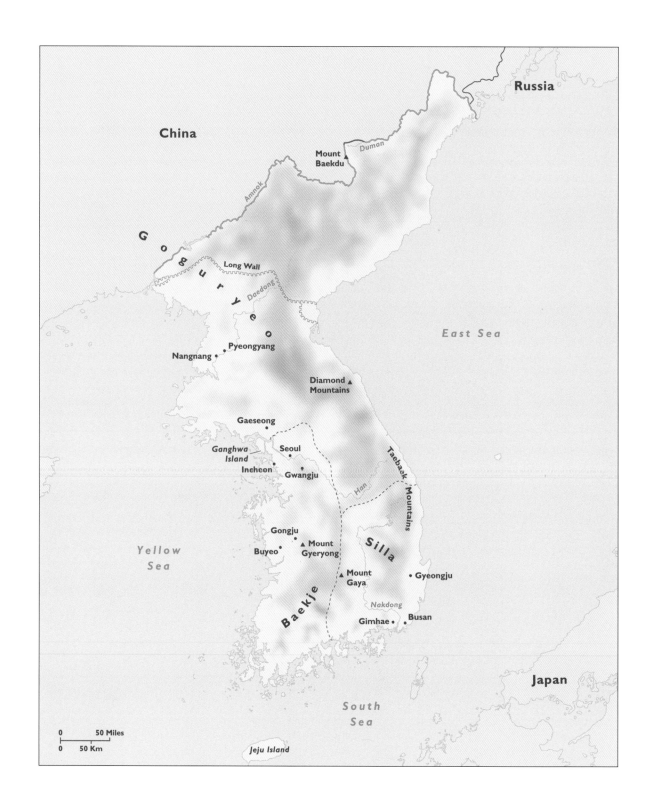

Comb-pattern Vessels of the Neolithic Age

As hunting and gathering gave way to farming, the need for vessels in which to store food and water arose. The earliest vessels in Korea were low-fired earthenware, which had been in use from the Neolithic Age. Judging from the earthenware excavated from the Gosan-ri remains on Jeju Island,[1] their first appearance in Korea might date back to 10,000 B.C. The Neolithic Age of the Korean Peninsula began around 8000 B.C., and comb-pattern earthenware vessels emerged about 4500 B.C., in the latter part of this period. These vessels spread throughout the Korean Peninsula, replacing earlier regional styles of earthenware, such as those of the Gosan-ri type, as well as those decorated with appliqué designs.[2] Today, comb-pattern earthenware vessels are recognized as the representative earthenware of the Neolithic Age in Korea.

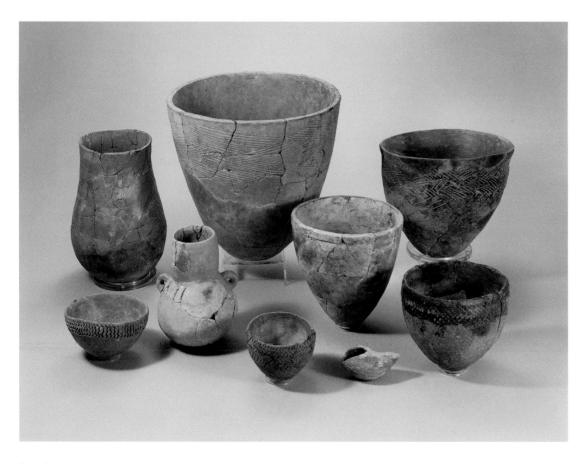

Figure 1

Comb-pattern earthenware of the southern
region, earthenware, height: 11 ¼ inches
(28.4 cm) (upper right).

Typical comb-pattern vessels are characterized by a pointed bottom and a conical body that gradually widens toward the mouth. This form is often called *chimjeobal-hyeong* (*chim*=point; *jeo*=bottom; *bal*=bowl or vessel; and *hyeong*=form or shape). Their surfaces are decorated with a variety of geometric patterns incised in parallel slanting lines that resemble a pattern made by a comb. The way these vessels are decorated plays an important role in determining their dates. Initially, different designs were applied to the vessel's mouth, body, and bottom. These decorative differentiations gradually waned during the latter part of this period, and decoration was eventually confined to the vessel's mouth area.

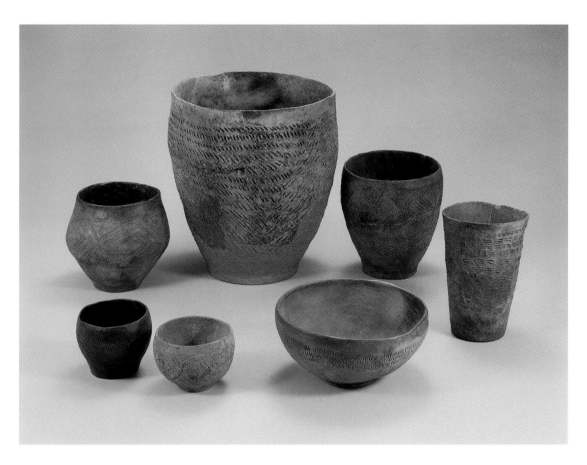

Figure 2

Comb-pattern earthenware of the northern
region, earthenware, height: 6 ½ inches
(16.5 cm) (right).

These comb-pattern vessels show several regional characteristics that can be divided into four groups: Northeast, Northwest, Midwest, and South. The earliest examples of earthenware have been discovered in the southern regions of Korea (fig. 1). Gosan-ri earthenware has been found on Jeju Island, and Dongsam-dong earthenware has been found in Busan. Vessels with appliqué decorations, as well as other older styles, have also been discovered along the southern coastal area. The shell mounds of Jodo Island are yet additional crucial sites where early artifacts have been uncovered. Some of these vessels illustrate the mutual influence of Korea and Japan. Yet all of these southern styles were ultimately replaced by comb-pattern vessels. In the northeastern and northwestern regions, the most common vessels of the time were flat-bottom bowls with everted mouths (fig. 2). Vessels of this style have been discovered at the Seopo harbor sites in Unggi and the Osan-ri sites in Yangyang.

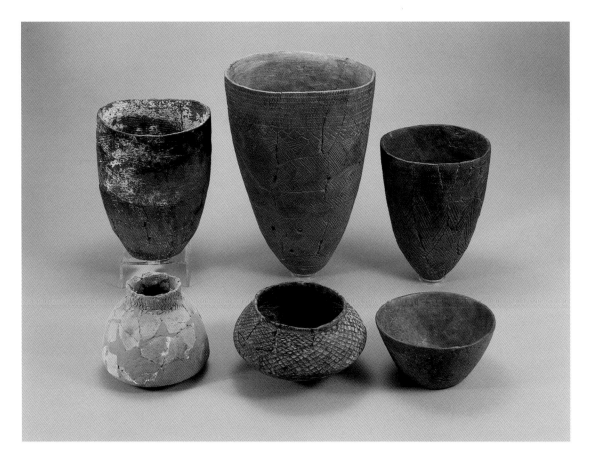

Figure 3
Comb-pattern earthenware of the
midwestern region, earthenware,
height: 11 ¼ inches (28.4 cm) (upper left).

The midwestern region is known to have produced the most typical style of earthenware: comb-pattern vessels with pointed bottoms (fig. 3). The main site where these vessels were recovered is Amsa-dong in the Han River basin in Seoul. Many scientific excavations have been conducted at this important site since its discovery in 1925. These excavations have uncovered several cultural strata, including those from various periods from the Neolithic Age and the Bronze Age to the Baekje of the Three Kingdoms period. About twenty-five dwelling sites from the Neolithic Age have also been discovered there. These subterranean huts had sandy floors and consisted of a four-sided space with rounded corners. Pillars erected in a conical shape supported the roof. Inside these huts was a round hearth constructed of river boulders, and some huts displayed traces of stairs at the entrance area. The earthenware excavated from Amsa-dong shows clearly the evolution of the comb-pattern design over time. With the advent of the Bronze Age, about 1000 B.C., Neolithic comb-pattern earthenware began to fall out of favor. It was gradually replaced by sturdier, unadorned earthenware made of clay mixed with a large portion of quartz.

Notes

1

The History and Culture of Jeju (Jeju: Jeju National Museum, 2001), 33.

2

Gosan-ri earthenware is a unique type of earthenware from the Neolithic Age that has been found in the Gosan-ri site on Jeju Island. Organic substances, such as vegetable stems, are included in the construction of the earthenware. The organic matter burns away during the firing process, leaving only their patterned marks on the surface. This type of earthenware is also found in the Chung-do Ojin-ri site in Korea's North Gyeongsang Province and in Russia's Amur site, which contained earthenware that were made even before 10,000 B.C.

Plate 1

Comb-pattern Vessel, 4000 B.C.,
Neolithic Age (8000 B.C.–1000 B.C.),
earthenware decorated with comb-pattern,
height: 19 ¾ inches (50.2 cm), National
Museum of Korea, Amsa 292.

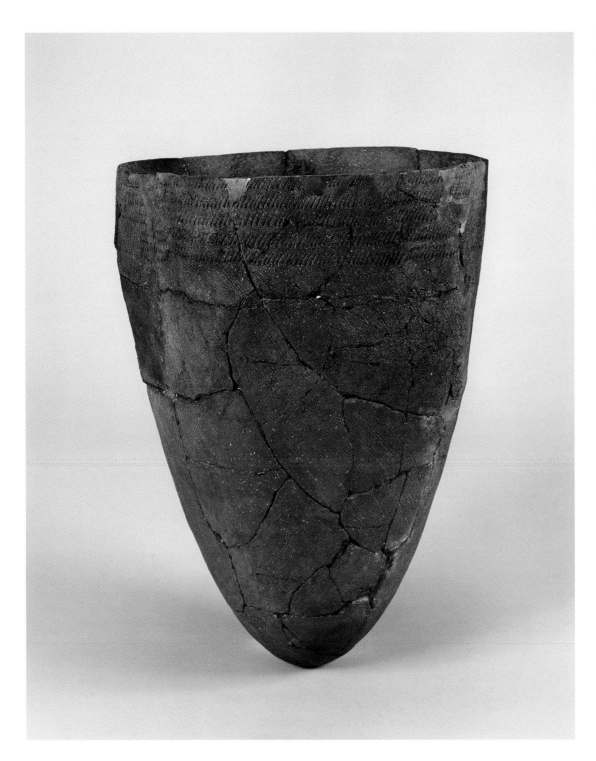

This comb-pattern vessel with a
pointed bottom is a typical example
of the Neolithic period's Amsa-dong-
style earthenware that has been
excavated from the midwestern
regions of the Korean Peninsula.
Its reddish-brown color is derived
from sandy clay, containing large
amounts of quartz; it was fired
in the open air or in open kilns
at low temperatures.

Plate 2
Red Burnished Jar, 5th–6th century B.C.,
Bronze Age (1000–300 B.C.), earthenware,
5 ½ × 3 ¼ inches (14 × 8 cm), National
Museum of Korea, Sinsu 2661.

The shape and color of this vessel is representative of Bronze Age earthenware in Korea. The jar's red color was formed by a mixture of oxidized iron and water that was applied and then fired in an open kiln. Because of the extra effort required to make these vessels, red burnished earthenware such as this piece probably served special funerary or ritual purposes. These kinds of jars have been excavated from tombs and dwelling sites located mainly in the southern area of Korea. This particular jar was excavated from North Gyeongsang Province. Red burnished earthenware were produced until a new ceramic manufacturing technique that used airtight kilns was introduced between the first century B.C. and the first century A.D.

Stoneware of the Three Kingdoms Period

Several kinds of earthenware, including the earliest varieties—comb-pattern vessels of the Neolithic Age, plain pottery of the Bronze Age, those with beater marks, and those of the early Iron Age—served as the basis of the stoneware of the Three Kingdoms period (57 B.C.–A.D. 668). The term "stoneware" indicates vessels made from tempered clay mixed with water and fired in a kiln. The stoneware of the Three Kingdoms period[1] refers to those high-fired vessels made in the kingdoms of Goguryeo, Baekje, Silla, and Gaya. These kingdoms' territories spread throughout the Korean Peninsula and the Chinese Liaodong Peninsula.

The stoneware of the Goguryeo kingdom has been excavated from Primorskij Kraj in Russia, as well as in Siberia, the Liaodong Peninsula in China, and the midnorthern part of the Korean Peninsula. Some of the distinctive features of Goguryeo stoneware include the lug-shaped handle, flat bottom, burnished surface, and blackish-gray or yellowish-brown color. Among the Three Kingdoms, Goguryeo was the first to produce stoneware with a yellow lead glaze. Although Goguryeo stoneware was originally seldom decorated, during the fourth and fifth centuries, saw-tooth, lattice, concentric-circle, and wave designs began to embellish the shoulders of these vessels. After the sixth century, these embellishments included dark patterns that had been smeared onto the vessels' surfaces.

Some of the representative stoneware forms of this kingdom include jars with four lug-shaped handles (fig. 1), three-legged cylindrical vessels, egg-shaped jars, and steamers. Unlike the stoneware of the other kingdoms, those of Goguryeo lack pedestals. While many of the Baekje, Silla, and Gaya stoneware forms are pedestal cups and stands with a strong ceremonial character, the Goguryeo vessels have a more utilitarian character.[2] After the mid-sixth century, Goguryeo bowls, water jars, dishes, and chimneys influenced Baekje stoneware during the Sabi period.[3]

Judging from the stoneware excavated from the central and the southwestern parts of the Korean Peninsula, Baekje developed the widest range of stoneware forms among the Three Kingdoms. Baekje stoneware tends to have a practical nature, and yet manages to retain softness and grace in its style. The Baekje kingdom is divided into three periods—the Hanseong period (third century–475),[4] the Ungjin period (475–538), and the Sabi period (538–660)—which are named for the kingdom's successive capitals. In each of these periods, Baekje stoneware showed distinct stylistic features.

During the Hanseong period, when the capital was located in what is present-day Seoul, vessels regarded as unique to Baekje were created. These vessels include black burnished vessels (fig. 2), vessels with three legs, jars with short necks and vertical mouth rims, egg-shaped jars, and pedestal cups. The egg-shaped jars were used in everyday life, while the black burnished vessels, resembling highly valued lacquer ware, were used by the ruling class of the time.

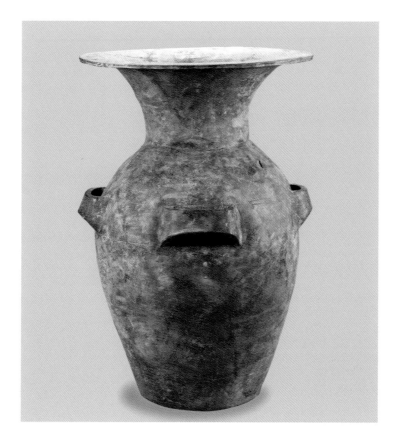

Figure 1
Jar with Four Handles, 5th century,
Three Kingdoms period: Goguryeo
(37 B.C.–A.D. 668), earthenware,
height: 23 ¼ inches (59 cm),
Seoul National Museum.

During the Ungjin period, when the capital was located in what is now known as Gongju, South Chungcheong Province, these black burnished vessels and egg-shaped jars disappeared, and pedestal cups, flat-bottomed cups with covers, dishes with three legs, jars, bottles, and stands were made. While three-legged dishes from the Hanseong period have been excavated from dwelling sites, those dating from the Ungjin period have been excavated in quantities from tomb sites. Cylindrical stands produced during this time acquired a refined hourglass shape, emphasizing their elegant curvatures. In the Nonsan region, round-bottomed jars and bowl-shaped stands have been found that testify to a ceramic culture with strong regional differences.

During the Sabi period, when the capital was located in what is now Buyeo, South Chungcheong Province, various forms of stoneware were used, such as three-legged vessels, bottles, jars, pedestal cups, cups, stands, vessels with extended rims, bowls with lids, and dishes. Ink stones, oil lamps, urinals, and other utilitarian items were also fabricated. During this time, ceramic manufacturing became standardized and specialized, as indicated by the uniform sizes of the large numbers of grayish-white vessels with extended rims and lid-ded bowls that have been excavated mainly from dwelling sites. In addition, the earliest burial urns of the Three Kingdoms were made in Baekje, where cremation became popular due to the influence of Buddhism.

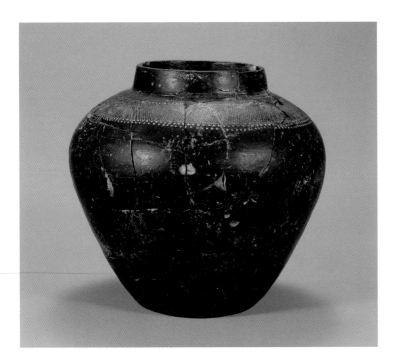

Figure 2

Black Burnished Vessel, 4th century, Three Kingdoms period: Baekje (18 B.C.–A.D. 660), earthenware, height: 6 ¾ inches (17.1 cm), Korea University Museum.

The Gaya ceramics excavated from the western part of the Nakdong River basin are almost identical to the Silla vessels. However, by the fifth century, unique features of the Gaya vessels began to appear. Although, at first, round jars had been Gaya's dominant form, gradually various other ceramic shapes began to develop that were characterized by a soft curvature, as seen here in a pedestal cup with a trumpet-shaped foot decorated with long rectangular apertures (fig. 3). Gaya also produced stoneware sculptural vessels modeled after human figures, animals, boats, carts, shoes, houses, and other forms. These vessels were not meant for everyday use, but for burial as funerary objects. After being used in rituals to pour wine or water, they were buried as symbolic representations of ardent wishes for peaceful repose or of the ascension of the deceased in the afterlife.[5] The stoneware styles of Gaya were transmitted to Japan, where they had a direct influence on the production of Sueki ware, the representative stoneware of the Japanese Kofun period.[6]

Like Gaya stoneware, Silla stoneware excavated from the eastern part of the Nakdong River basin displayed distinctive features only after the fifth century. Silla pedestal cups have a ladderlike straight foot with staggered square apertures. The neck and shoulder of Silla long-necked stoneware meet at a right angle, unlike those of Gaya, which are connected by a more gentle and refined curve. Silla stoneware also features a range of incised designs. Earlier Silla stoneware vessels were decorated with only wave patterns and dotted-line patterns incised on the neck, shoulder, or lid, but gradually various other designs, including stripes, and triangular and saw-tooth designs, became popular. However, these designs eventually were limited to those based on semicircles and triangles.

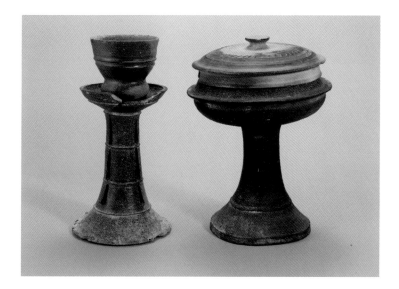

Figure 3
Pedestal Cup, Wide Mouth Pot and Stand, 5th century, Three Kingdoms period: Gaya (42–562), stoneware, height: 8 ¾ inches (22.4 cm) (right), Changwon National University Museum.

Silla also produced sculptural forms like those of Gaya. These vessels were made to serve as vehicles to guide the souls of the dead to the netherworld. Some examples include the horse and rider and the boat-shaped stoneware excavated from Geumnyeong-chong (Gold Bell Tomb) (fig. 4), and the boat-shaped and cart-shaped stoneware excavated from Gyerim-no Street in Gyeongju. The vessels in the shape of a horse and rider depict a master and an attendant on horseback with equestrian gear, including a bridle, saddle, mudguard, harness, and so on. They provide important clues, revealing not only cultural elements, such as clothing and equipment, but also the prevailing views of the afterlife at the time.

With the unification of the Three Kingdoms by Silla in 668, stoneware underwent many changes.[7] The traditions of Goguryeo and Baekje were gradually absorbed into the Unified Silla style, which features a stamped design. During the Unified Silla period (668–935), various forms of stoneware were made that reflect the vigorous exchanges with the Chinese Tang dynasty (618–906) and the strong influence of Buddhist art. The finest among them were burial urns with stamped designs covering their surfaces. Toward the end of this period, these stamped designs were eliminated in favor of plain, unadorned stoneware vessels. Eventually, as stoneware resembling celadon began to be produced, the styles of Unified Silla gradually evolved into that of Goryeo ceramics.

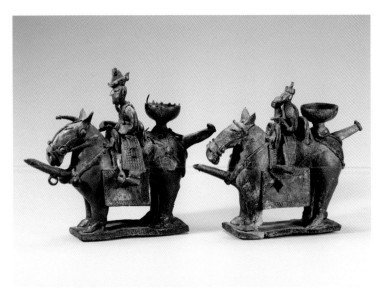

Figure 4

Vessels in the Shape of a Horse and a Rider, 6th century, Three Kingdoms period: Silla (57 B.C.–A.D. 668), stoneware, height: 11 ⅝ inches (29.4 cm) (left), National Museum of Korea, National Treasure No. 91.

Notes

1

In this period, the opposing kingdoms of Goguryeo, Baekje, and Silla were established on the Chinese Liaodong Peninsula and the Korean Peninsula. Goguryeo ruled over parts of Manchuria, Siberia, the Liaodong Peninsula, and the northern part of the Korean Peninsula; Baekje ruled the southwestern part of the Korean Peninsula; and Silla ruled the southeastern part. Although Gaya had existed on the south-eastern part of the Korean Peninsula, it was conquered by Silla in 562 before it developed into a kingdom from confederated states. Therefore, this period is called the Three Kingdoms period.

2

Earthenware of the Ancient Korea (Seoul: The National Museum of Korea, 1997), 9.

3

Encyclopedia of the Korean Archaeology (Seoul: National Research Institute of Cultural Heritage, 2004). In particular, the earthenware chimney excavated from Neungsa in Buyeo, South Chungcheong Province, resembles the Goguryeo chimney excavated from M2325 tumulus in the Usanha tomb complex in Jian, China. This correlation demonstrates the influence of Goguryeo culture. Kyudong Kim, "Study on the Baekje Stoneware Chimney," *Scientific and Technical Researches of Archaeology* 8 (2001).

4

According to *Samguk-sagi* [*The History of the Three Kingdoms*], Baekje was founded in 18 B.C. However, archaeological excavation results and other research materials suggest that the development of Baekje into an ancient kingdom took place during the reign of King Goi in the third century.

5

Earthenware of the Ancient Korea, 136.

6

The Kofun period was from 200–552. A group of Gaya potters are presumed to have traveled to Japan, where they introduced the technology needed to manufacture Sueki ware, the earliest form of hard-fired stoneware in Japan. Sadamori Hideo, "Early Sueki ware and Stoneware from the Korean Peninsula," in ibid., 167–69.

7

Baekje was conquered by Silla and the Chinese Tang dynasty in 660, and Goguryeo was conquered in 668. The Three Kingdoms of Goguryeo, Baekje, and Silla were thus transformed into Unified Silla.

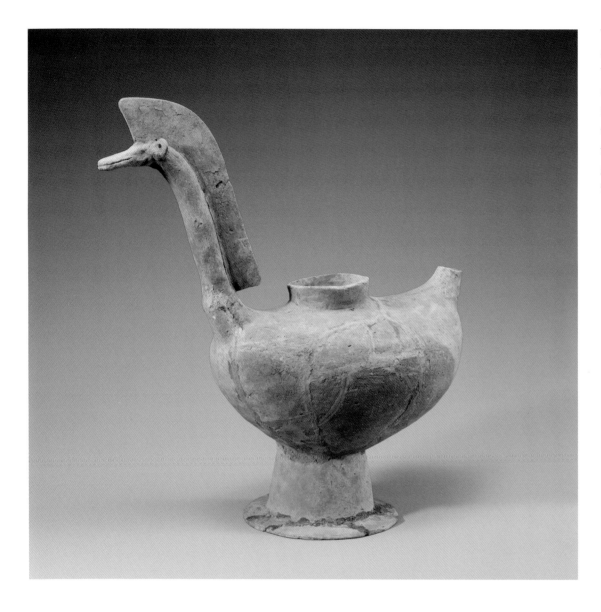

Plate 3

Duck-shaped Vessel, 4th century, Three
Kingdoms period: Silla (57 B.C–A.D. 668),
earthenware, height: 17 ¼ inches (44 cm),
National Museum of Korea, Hongsan 656.

This hollow vessel is in the shape
of a duck standing on one foot.
The back of the duck reveals the
mouth to a cup, and a hole has
been made on the tail. Duck-shaped
vessels such as this one are assumed
to be related to funerary rituals for
guiding the soul of the deceased
from this world to the netherworld.

Plate 4

Jar, 5th–6th century, Three Kingdoms
period: Goguryeo (37 B.C–A.D. 668),
stoneware, height: 11 inches (28 cm), National
Museum of Korea, Bongwan 13882.

This jar has a flat bottom, a long
egg-shaped body with a short neck,
and two lines encircling the center of
the body. The flat bottom is one
of the characteristics of Goguryeo
stoneware, demonstrating its strong
practical nature. Jars with a long egg-
shaped body, such as this jar, have
been excavated mostly from dwelling
sites, indicating that they served
functional, everyday purposes.

Plate 5

Jar, 5th century, Three Kingdoms period:
Baekje (18 B.C–A.D. 668), stoneware,
height: 8 ¼ inches (22.3 cm), Gwangju
National Museum, Gwang 1168.

This jar was excavated from the
Yeongsan River basin in the south-
western part of the Korean Peninsula.
The marks on the vessel surface were
made by repeated strikes with a
beater. This process strengthened
the vessel. The design made by
beater marks is one of the features
of stoneware excavated from the
Yeongsan River basin and resembles
the footprints of water birds.

Plate 6

Jar, 4th century, Three Kingdoms period:
Gaya (42–562), stoneware, height: 9 ½ inches
(24 cm), National Museum of Korea, Jeung 9.

This lidded jar with a handle has
a pleasing curvature. The surface
of the jar is decorated with a design
created by a series of dots arranged
in oblique lines. This decorative design
is representative of Gaya stoneware,
and the vessel's curving shape is
distinctly different from the straight
lines of Silla stoneware.

Plate 7

Burial Urn, 8th century, Unified Silla dynasty
(668–935), stoneware, height: 8 ¼ inches
(21 cm), National Museum of Korea, Deoksu
5199.

This burial urn has an alms-bowl-shaped body and a lid with a jewel-shaped knob. The water-drop pattern and the pendant pattern stamped or impressed over the entire surface enhance the sense of luxuriousness. This type of burial urn was used to hold the ashes and bones of cremated Buddhist devotees.

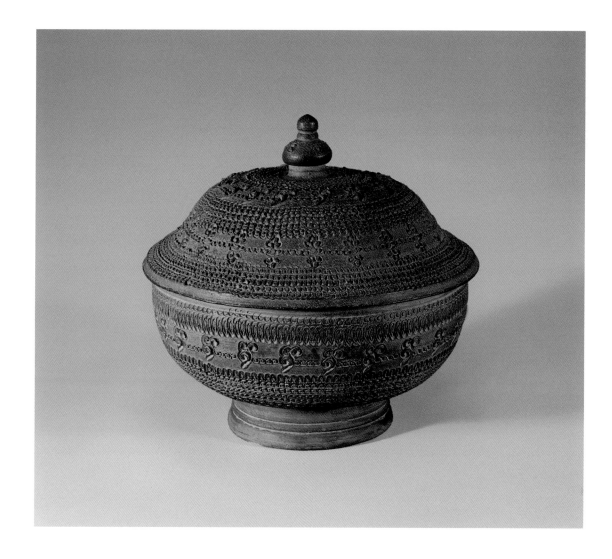

The Gold Crowns of Silla

Silla is often called the Kingdom of Gold, and gold crowns are the most apt symbol of this kingdom.[1] Worldwide, at least ten ancient gold crowns from this part of the world are known to exist. Among them are six Silla gold crowns, five of which were excavated in Gyeongju from the tombs of Geumgwan-chong (Gold Crown), Geumnyeong-chong (Gold Bell), Seobong-chong (Lucky Phoenix), Cheonma-chong (Heavenly Horse), and Hwangnam Daechong (Great Hwangnam); the sixth was found in Gyo-dong.

These gold crowns were made during a period of approximately a hundred years, from the second half of the fifth century to the first half of the sixth century. During this period, Silla had four kings.[2] The fact that five gold crowns have already been unearthed from royal tombs in Gyeongju, even though only about 20 percent have been excavated and surveyed, suggests that gold crowns were not made exclusively for kings, but for other members of the royalty as well. Other supporting hypotheses indicate that the northern tomb of the twin tumuli of Great Hwangnam was that of a queen; the Lucky Phoenix tumulus was that of a female member of the royal family; and the Gold Bell tumulus was that of a prince.

The excavation reports reveal that the lower parts of the headbands of these crowns were found over necklaces and the upper part of chest ornaments (figs. 1 and 2). Thus, Silla gold crowns were not worn above the forehead but covered the entire head, including the face. This suggests that these gold crowns were burial objects made specially for the deceased.[3]

Symbols of trees, antlers, and birds, as well as comma-shaped pieces of jade, are presented on these crowns. The crown from the Lucky Phoenix tomb also has an unusual inner cap made of long crossed gold plates with depictions of three phoenixes perched on three stylized tree branches (fig. 3). Except for the one excavated from Gyo-dong, the crowns share a similar design. They have headbands that support five stylized trees, three in the shape of the character *chul* (出) and two in the shape of antlers. Ancient people in Korea, central Asia, and Siberia believed that the tree was the pillar of the universe connecting Heaven, the Earth and the Underground.[4] In Siberia, where the Sarmatian gold crown was found, sky-high birch trees were considered sacred as the "Tree of Life" or the "Tree of the World."[5] Also in Siberia, antlers were thought to be the instruments capable of contacting the spiritual realm and were used to ornament the head of the high priest.[6] Birds were also seen as intermediaries between Heaven and Earth.[7] Thus, trees, antlers, and birds symbolically linked this world and the afterworld.

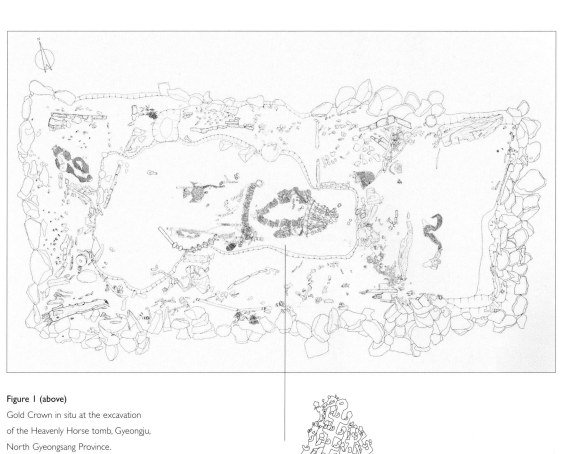

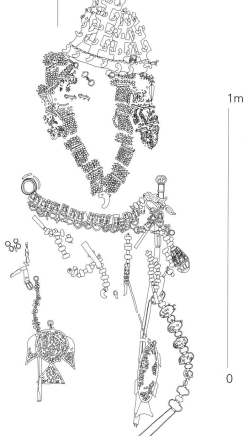

Figure 1 (above)
Gold Crown in situ at the excavation
of the Heavenly Horse tomb, Gyeongju,
North Gyeongsang Province.

Figure 2 (right)
Detail of figure 1, Gold Crown
at excavation site.

1m

0

Each of the crowns' vertical elements terminates in a jewel form and is decorated with one or two continuous lines of dots along the edges. The edges of the headband are also decorated with continuous rows of dots, wave designs, or saw-tooth patterns made by a pointed tool. A pattern of concentric circles made with a tubular tool is also evident. Round gold spangles and comma-shaped pieces of jade, called gogok,[8] are suspended at regular intervals on the surface of these crowns. The gogok not only symbolized wealth and power, but also represented the high social status of the wearers when suspended on their gold crowns, earrings, bracelets, girdles, necklaces, and chest ornaments. Although there are many theories about the origin of gogok, a prevailing opinion is that they represent animal embryos, primeval life forms, and thus are symbolic of ardent wishes for abundance, fecundity, and prosperity.[9]

The origin of these crowns' symbols is unclear. Some believe that they originated from Siberia, because the antlers and the pendants decorating a Siberian shaman's crown greatly resemble those of the Silla gold crowns.[10] Furthermore, the girdles that were excavated with the gold crowns are thought to be related to the material culture of the Goguryeo kingdom and of the Sanyan dynasty of the Xianbei tribe.[11] Thus, the gold culture of Silla may have been influenced directly by Goguryeo and indirectly by the Sanyan dynasty.[12]

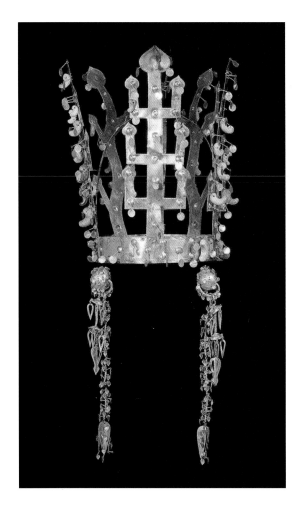

Figure 3

Gold Crown, 5th century, from the Lucky Phoenix tomb, Gyeongju, North Gyeongsang Province, Three Kingdoms period: Silla (57 B.C.–A.D. 668), gold, height: 12 ⅛ inches (30.7 cm), National Museum of Korea. Photograph courtesy Gyeongju National Museum.

Notes

1

There are a total of eight ancient gold crowns of Korea. Two crowns are excluded from this number because they are assumed to be Gaya crowns: one is the gold crown in the Okura collection of the Tokyo National Museum, and the other is a gold crown in the collection of the Ho-Am Art Museum (now the Leeum, the Samsung Museum of Art). Kim Byeongmo, *Secret of Gold Crown* (Seoul: Blue History, 1998), 65–75. *Mysterious Kingdom of Gold, Silla* (Gyeongju: Gyeongju National Museum, n.d.), 272.

2

The four kings of this period were Nulji Maripgan (417–457), Jabi Maripgan (458–478), Soji Maripgan (479–499), and Jijeung Maripgan (500–513). Maripgan is a title that meant "king."

3

Lee Hansang, *Kingdom of Gold, Silla* (Seoul: Gimm-Young, 2004), 66–72. Junichi Manome, "Theory of Dating Gold Crown with Crown Ornaments from Ancient Silla Tumulus in Gyeongju," *Research Anthology of Ancient Times* 4 (1995).

4

Heo Hoesuk, "Study on Sodo, the Sacred Area of Samhan Period," in *Kyunghee Historical Science*, vol. 3 (Seoul: Kyunghee University Historical Science Society, 1972), 6–7.

5

Sarmatians were a multitribal confederacy of Western Scythia that were active from the sixth century B.C. to the forth century A.D. The richest tombs and the most significant finds of Sarmatian artifacts have been recorded in the Krasnodar Krai of Russia.

6

Lee, *Kingdom of Gold, Silla*, 82–83. The Sarmatian gold crown was excavated from the Khokhlach tumulus group in Novocherkassk, Rostov Oblast, to the north of the Black Sea. At the center of the crown band is a large tree, and four smaller trees and four animals are placed in bilateral symmetry. Connecting the Sarmatian gold crown and Silla gold crowns is difficult, for they have more than four hundred to five hundred years between them; however, the two crowns do share similar elements, such as the style of the leaves dangling on branches and the gogok ornaments on the crown band.

7

Lee, *Kingdom of Gold, Silla*, 84.

8

In use since the Neolithic age, gogok are ornaments made of crescent-shaped jade, which is perforated and suspended with a string.

9

Lee Insuk, "Study on the Prehistoric *Gogok* in Korea," in *The Collection of Treatises Commemorating the Retirement of Professor Kim Wonyong*, vol. 1 (Seoul: Iljisa, 1987), 365.

10

Kim, *Secret of Gold Crown*, 54.

11

The Xianbei were an ancient nomadic tribe that resided in North Asia.

12

Lee, *Kingdom of Gold*, 226.

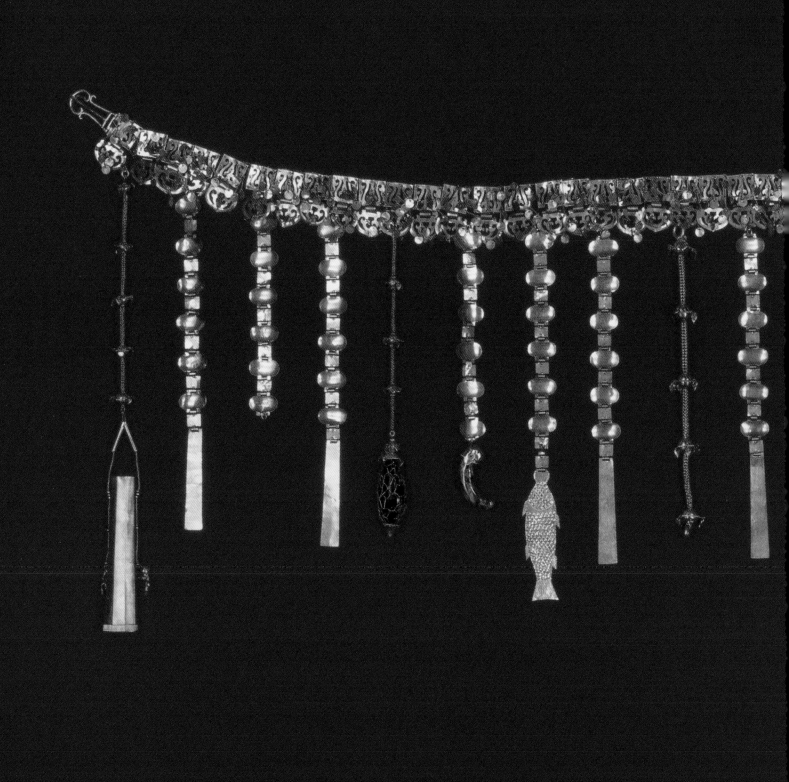

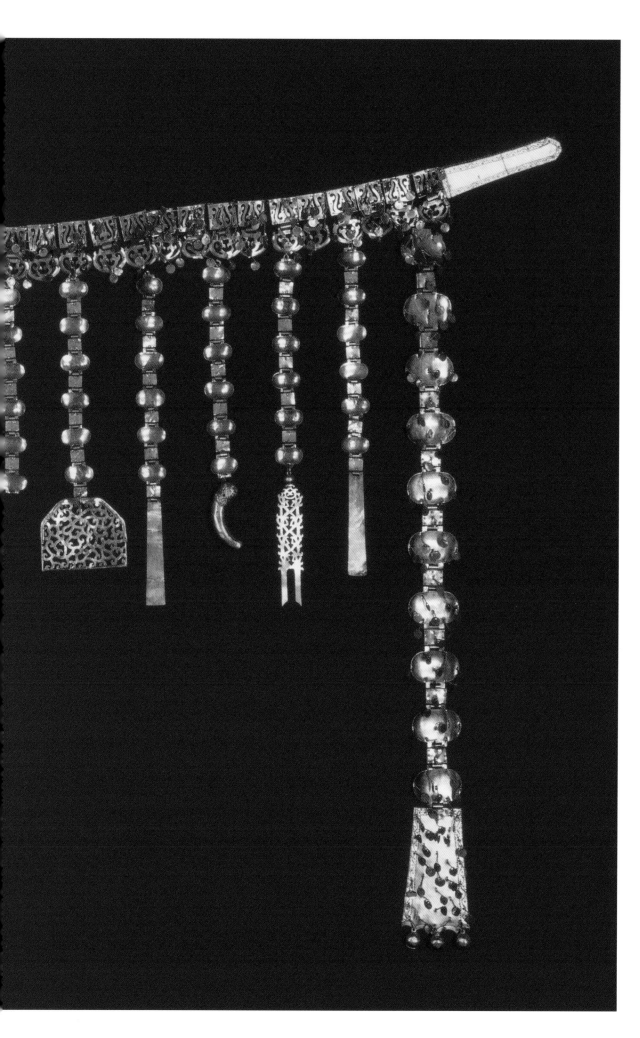

Plate 8

Girdle with Pendants, 5th century, from the
Geumgwan-chong (Tomb of the Gold Crown)
Gyeongju, North Gyeongsang Province,
Three Kingdoms period: Silla (57 B.C.–A.D. 668)
gold and jade, length: 47 ¼ inches (120 cm),
National Museum of Korea, Bongwan 9416,
National Treasure No. 88.

This girdle with pendants is made of
a thin gold sheet. It is composed of
forty elements, consisting of square
plaques, buckle-shaped loops, a thong
and a buckle at the end of the belt,
and seventeen lines of pendants.
A fish, a dragon, an incense pouch,
gogok, and other ornaments are
attached to the end of each pendant.
Fish and gogok symbolize fecundity
and the preciousness of life.

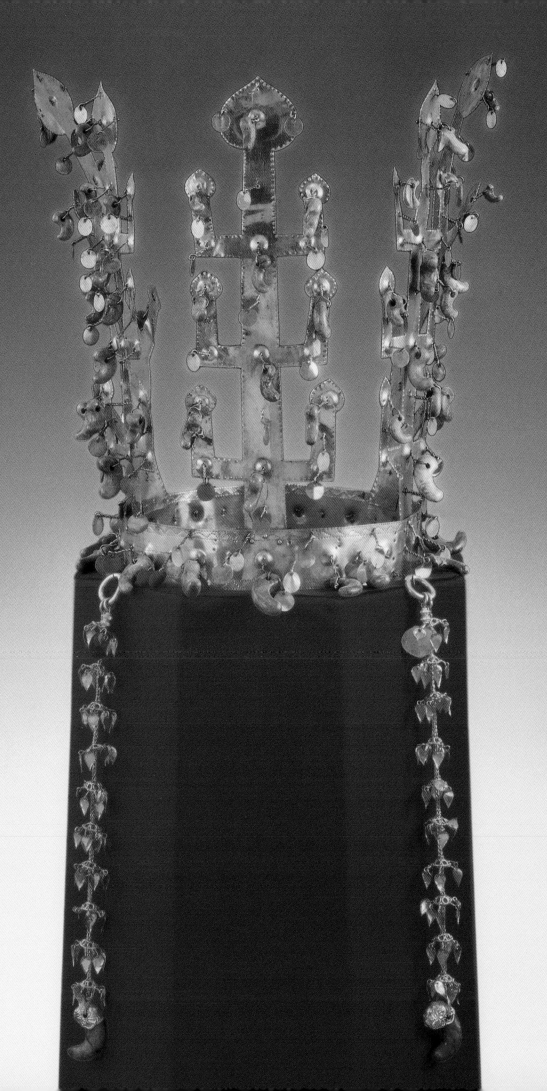

Personal Ornaments

Although personal ornaments were made at first with natural materials kept in their original forms, both the material and forms of these ornaments eventually underwent various changes along with the development of civilization. The chapter "Eastern Barbarians," in *Book of Wei, the Records of Three Kingdoms* reports that beads were sewn on clothes or used as earrings and necklaces by early Koreans. Since the time of Korea's Three Kingdoms period (57 B.C.–A.D. 668), as a result of the progress made in metalwork technology, excellent metal craftworks, such as headdresses, earrings, necklaces, and girdle ornaments, were made and handed down. A number of surviving ornaments illustrate that personal adornments had been popular in early society. These ornaments gradually developed into symbols of wealth, power, and social status beyond their initial decorative and talismanic functions.

Compared to those from the Three Kingdoms period and subsequent Unified Silla period (A.D. 668–935), not as many ornaments from the Goryeo dynasty (918–1392) have survived. Nevertheless, among the Goryeo examples are girdles, bracelets, hairpins, and headdresses (figs. 1 and 2). The metalwork technology of this dynasty was highly developed, and even extremely ingenious, according to Xu Jing in his *Xuanhe fenshi Gaoli tujin* [*Illustrated Record of the Chinese Embassy to the Goryeo Court during the Xuanhe Era*].[1]

Later, in the Joseon dynasty (1392–1910), personal ornaments that combined practical use, such as small knives enclosed within ornate covers, acupuncture-needle cases, and sewing-needle cases, were made in large quantities. Other kinds of personal ornaments produced during this time include pendants, chignon pins, pouches, and incense pouches; different ornaments were worn in accordance with a wearer's gender, social status, and age.

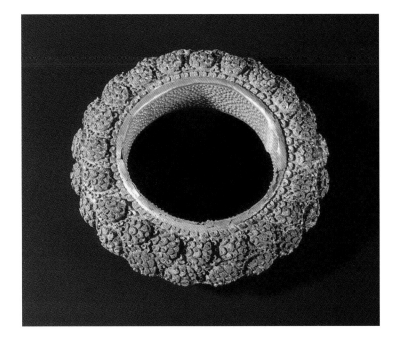

Figure 1

Bracelet with Chased Flower Design, 12th century Goryeo dynasty (918–1392), gilt silver, diameter: 3 ¾ inches (9.6 cm), National Museum of Korera.

Among the personal ornaments from the Goryeo dynasty, small metal ornaments of pure gold, silver, or bronze have survived in considerable numbers (fig. 3). The silver and bronze ornaments are frequently gilded and have small holes that may have been used for attaching them. Their exact usage is not yet clear, but they were probably sewn on cloth or clothes because traces of fiber remain on the backs of some ornaments. What is certain, however, is that they were eventually buried in the ground, judging from the rust on their surfaces.[2]

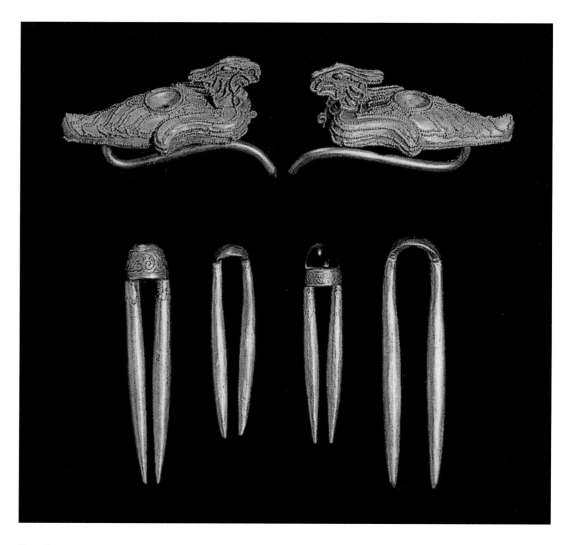

Figure 2
Hairpins, 12th–13th century, Goryeo dynasty
(918–1392), gold and gilt bronze, length:
1 ⅞ inches (4.9 cm), National Museum
of Korea.